Jeremy Reed's earlier collections of poetry include *By the Fisheries*, which won the Somerset Maugham Award in 1985, *Nineties* and *Red-Haired Android*. He has written illuminating studies of Rimbaud, de Sade and Lautréamont, produced acclaimed translations of Novalis, Montale and Cocteau, and in *Madness – The Price of Poetry* has explored the poetic achievements of Christopher Smart, Clare, Hopkins, Baudelaire, Rilke, Lowell, Roethke and Hart Crane. His latest novel, *Diamond Nebula* (Peter Owen 1994), features J.G. Ballard and two of the subjects of these *Pop Poems*, Bowie and Warhol.

A graduate of Caius College, Cambridge, Mick Rock is best known for his classic rock album covers, including Lou Reed's *Transformer*, The Stooges' *Raw Power*, and *Queen II*. The first comprehensive collection of his early work, *Mick Rock – A Photographic Record 1969-1980*, will be published in Autumn 1994, followed in 1995 by his first book of erotic images, *The Soft Collection*. Since the late 1970s Mick Rock has lived and worked in New York City as a photographer, art director and maker of videos.

OTHER ENITHARMON PUBLICATIONS BY JEREMY REED

Poetry
Saints and Psychotics (1979)
A Man Afraid (1982)
The Secret Ones (1983)
Skies (1985)
Dicing for Pearls (1990)

Novel
The Lipstick Boys (1984),
with an introduction by Kathleen Raine

Translations
Novalis: *Hymns to the Night* (1989),
with an introduction by David Gascoyne

Jean Cocteau: *Tempest of Stars – Selected Poems* (1992),
with images by David Austen
(also available as a de luxe limited edition)

*

Forthcoming in 1995
Fast Behind Dark Shades: Selected Poems 1987-93

JEREMY REED
POP STARS

PHOTOGRAPHS BY
MICK ROCK

with an introduction by Marco Livingstone

ENITHARMON PRESS LONDON 1994

for
Marco Livingstone

First published in 1994
by the Enitharmon Press
36 St George's Avenue
London N7 0HD

Distributed in Europe
by Password (Books) Ltd
23 New Mount Street
Manchester M4 4DE

Distributed in the USA
by Dufour Editions Inc.
PO Box 449, Chester Springs
Pennsylvania 19425

Text © Jeremy Reed 1994
Images © Mick Rock 1994
Introduction © Marco Livingstone 1994

ISBN 1 870612 29 9

Set in 10pt Palatino by Bryan Williamson, Frome,
and printed by
The Cromwell Press, Broughton Gifford, Wiltshire

Contents

The poems marked with an asterisk are accompanied by a photograph by Mick Rock.

Elvis Presley	11
For Marc Almond	12
Listening to Marc Almond	13
Syd Barrett*	14
Marc Bolan	17
David Bowie*	18
William Burroughs	21
John Cale	22
Nick Cave	23
Jean Cocteau	24
Leonard Cohen	25
Julian Cope	26
The Cure	27
Ray Davies*	28
Brian Eno	31
Marianne Faithfull*	32
Goth Pop	35
Debbie Harry*	36
Jimi Hendrix	39
Billie Holiday	40
Michael Jackson	41
Three Decades of Jagger*	42
The Jesus and Mary Chain	45
Brian Jones	46
John Lennon	47
Madonna*	48
Man Ray	51
Freddie Mercury*	52
Jim Morrison	55
Morrissey	56
The New York Dolls	57
Johnny Thunders*	58
Shooting a Pop Video	61
Nico*	62
Edith Piaf	65
Iggy Pop*	66
Prince	69
Lou Reed*	70

Keith Richards	73
The Rolling Stones	74
Roxy Music	75
The Sex Pistols*	76
Orange Disaster	79
Siouxsie and the Banshees*	80
Rock and Poetry	83
Patti Smith*	84
The Blue Hotel	87
The Stooges*	88
The Velvet Underground	91
Scott Walker	92
Andy Warhol	93
Neil Young	94

Introduction

From the time of Jeremy Reed's childhood in the 1950s, when rock'n'roll itself was in its infancy, visual artists have fought against received opinion of what constitutes respectable subject-matter and opened themselves increasingly to popular culture as a legitimate area of inspiration. For this process to take place, areas of mass entertainment previously regarded as low-brow, kitsch and lacking in intelligence – from pop music to Hollywood movies – had to begin to be taken seriously in their own right as forms capable of creative expression.

Initially without knowledge of each other's work, painters and collagists in both the United States and Europe began to use images of the pop stars that defined the new teenage culture. Elvis Presley, for instance, figured as early as 1955 in collages by the American Ray Johnson, who used the pages of magazines as the support for ink-stained objects of devotion; in the form of printed images pasted by the British artist Peter Blake onto the glossy, brightly coloured backgrounds of paintings in 1959, and alluded to in the fan's badges proudly worn by him in his self-portrait of 1961; in a 'décollage' of torn posters created in 1962 by the Italian *Nouveau Réaliste* Mimmo Rotella; and, most famously, from 1962 on Andy Warhol's silkscreened surfaces of mask-like inviolability and aloofness.

It was through Pop Art, in its various forms, that the stars of youth culture and of the burgeoning music industry infiltrated into higher levels, although the artists who dealt repeatedly with such subject-matter were surprisingly few and far between. Richard Hamilton's *Swingeing London* paintings of 1968-9, for instance, in which Mick Jagger and the art dealer Robert Fraser are being driven away handcuffed on drugs charges, stand in retrospect as powerful images of that libertarian period, but they are only peripherally concerned with the protagonist's status as a singer. Blake produced portraits of the Beatles, Bo Diddley, The Everly Brothers, The Lettermen, The Beach Boys and even of Frank Sinatra and Sammy Davis Jr. Warhol produced numerous variations on Elvis, in parallel with his images of other popular paradigms of glamour, fame or rebellion – including Marilyn Monroe, Elizabeth Taylor and Marlon Brando – but otherwise steered clear of musicians until the 1980s, with the exception of his Mick Jagger portraits of the mid-1970s. In the later 1960s,

when Pop Art had already secured its historical place, the British painter David Oxtoby set himself on a lifelong project of depicting the rock stars of his generation in a souped-up figurative idiom that paid homage to their energy and glamour. It was perhaps natural that pop stars, swept into public consciousness as much through their visual image as through their music, should have been turned into subject-matter for fine art and also the cinema long before the prejudices against such material could be overcome in other spheres. The astonishing growth of pop music journalism since the 1960s, from its inauspicious start in teeny-bopper fan magazines to the serious contributions of *Rolling Stone* and other publications, and on to the do-it-yourself enthusiasm of the punk fanzines, widened the appreciation of the audience while perhaps hindering a linguistic response on anything other than a documentary or interpretative level. Leonard Cohen's poetry and early novels aside, the rare forays of pop musicians into poetry or fiction – such as the poetry of Jim Morrison, John Lennon or even Patti Smith, Bob Dylan's experimental novel *Tarantula* (1971) and Nick Cave's best-selling novel *And the Ass saw the Angel* (1989) – have had little effect on the condescension displayed by the literary establishment towards the artistic value of pop music as a genre, which has continued generally to be regarded as outside the boundaries of serious literature.

The perceived gulf between journalism and literature has been paralleled during the past twenty or more years by the status accorded to photographers judged as artists and those regarded merely as photo-journalists on the fringe of the music industry. Yet Mick Rock's canny and compelling images of musicians, such as those reproduced in this book, have a rare capacity to externalize in visual form the quality of the music and the personality of its creators. It was not simply because of his friendship and proximity to David Bowie, Lou Reed, Iggy Pop and Freddie Mercury, among other luminaries of the 1970s and 1980s, that Rock devised the definitive images by which we remember them. His remarkable capacity to condense both the appearance and the character of a person into a single fixed image is repeatedly demonstrated: in Mick Jagger's concentration and lasciviously opened mouth; in the frailty and inward expression of Syd Barrett; in the sexual provocation of the young Madonna, photographed before she had released her first record; in the brittle gracefulness of Siouxsie Sioux. The photographic images in this

book, many of them reproduced here for the first time and chosen by Rock himself in response to Reed's evocative poetic portraits, provide eloquent testimony of a vision that transcends the circumstances in which they were taken. Rock's decision to print these images out of focus, and to overlay each of them with five scorch-marks, are tokens of his unwillingness to rest content with past successes. Each image is physically assaulted and presented as if through a haze of memory, taking us back to a vital encounter and retrieving a moment past for the present.

Reed has always taken pride in seeing how far he can walk out on a particular limb without losing his balance and falling off, and *Pop Stars* is no exception. He has often presented as his mentors and fellow travellers those free spirits who have chosen to exist at the fringes of respectability, such as Rimbaud, Lautréamont and the Decadents, the Surrealists and even de Sade. Most of the pop stars he admires, from the Velvet Underground or the Rolling Stones to Johnny Rotten and the Sex Pistols, from Ray Davies of The Kinks to Morrissey, and from Edith Piaf to Marc Almond, fall into similar categories of the depraved or angry renegade, of the sensitive witness, or of the passionate romantic living life to the full. Reed, moreover, has played with genres, such as that of the science fiction novel, that continue to be regarded as lacking in seriousness by the bureaucratic defenders of literature. His choice of subject-matter for this new collection of poems, however, is motivated not by provocation but by respect and a passionate commitment for the voices that have contributed to the world of his own imagination. While Pop Art may have given him licence to explore such material as legitimate for his own art, his identification with each musician as a fellow creator, and his profound disclosure of character and motivation, contrast greatly with the surface image and ironic detachment so assiduously cultivated by Warhol, the subject of one of his poems. *Pop Stars* as a collection entails far more than the translation of one art form into another. It can be described as the invention of a new genre all its own.

<div style="text-align: right;">MARCO LIVINGSTONE</div>

Elvis Presley

He's photographed against a Cadillac,
one of the many littering his park,
white shoes conspicuous against the black

jacket, the cliff edges around the quiff
broken by gelled strands, loose diagonals.
His posture's always informally stiff,

it seems to say, 'I am the first and last
to make music into a religion.
My virtue is in owning to no past,

and yet the present leaves me obsolete.'
The antebellum façade at Graceland
has two stone lions guarding the retreat;

the rooms are kitsch, an ersatz movie set,
no sound, no light, and yet the *mise-en-scène*
describes the man: wall-to-wall mirrors vet

the ostentation without commentary.
A red room, blue room, chandeliers, peacocks,
each piece has no familiarity,

but suggests someone filling in a space
eclectically, obsessed by the unreal,
catching sight of himself in a surface

in which a sculpture preens. His fall was long,
cushioned by chemical supernovas.
We listen. Who is that inside the song?

For Marc Almond

The lyric bounces from the street
into our hands as a red ball.
My poetry and your invasive voice
find somewhere a congruity,

the fifth side to a square; a catch
in regulated breath; the word
that flies off as a frightened bird
to live with others. You launch it through notes,

I keep it on the page. It's death
as a symbolic variant
provides the tension to create.
When words are there I walk clean through a wall.

Dejected hubris. It's a blue-blue note
I hear from a window in your street.
You might be composing an elegy
for pink culture, piano-smudging a beat

to have the blue tone lift. It rains outside.
I walk to meet the day as an idea
about the poem I'm writing.
Orange panopticons are like a sun

in the fruit market. It's a testing thing
this writing on one's nerves. Later I'll try
your 'Melancholy Rose' as a prelude
to a new mood that settles at evening.

Listening to Marc Almond

My inconsolably blue solitude;
all day I watch words arrive on the page
as though they are a stranger's, metaphors
with diamond interfaces, quantum light
transmitted by nerve impulses.
That way I get the inside, get to know
what stars come on at the interior.
And when I write I listen to the voice,
dear lovers of the only voice,
a diva's vocabulary of quixotic pain
reaching the small hurts we don't know are there
until they open. There's no other way
to go meet death, except through love, and risk
is the adventure. Last night in my dream
I carried a black swan in my arms
through crowded city streets. Today I'm where
the image jumps like sunlight on a roof,
and words surround me, notes that sometimes bruise
a nerve cell's blue lining. It's coming clear
the lyrics meet me mid-way, as I catch
the spin off from a line, and switch to how
love is inconstant, and the song goes where
two men in dresses stand under the rain,
an old pink taxi's brought them to the sea,
or something like that, and I'm lost again
right in the moment's desperate immediacy.

Syd Barrett

Exchange vertical for horizontal;
the man is always shifting laterally
towards the big dip. There's a little tree
planted somewhere, a mile before the drop
into a bottomless gorge where dead mules,
scrapped cars, a rotting elephant

are jostled by the torrent.
Madmen pick through the flotsam, poke about
for broken mirrors, books of nursery rhymes.
Reverse the years to 1966,

a ringleted, red velvet jacketed
voyou implodes with chemicals.
His mind's a pyrotechnical Van Gogh
exploding into brilliant fall-out,

he sinks a canoe on the Cam and swims
clutching a fuzzy radio.
He picks the water jewels out of his hair,
they are a gift for Emily. She lives

inside a vase, inside a tree,
each green oak leaf's a peacock's ocelli.
His burn out is so fast he watches it,
up on the fourteenth floor, waves a white sheet
to his blinding demise and scrambles down

into a wasteland. There is no one there,
the town is empty, evacuated
decades ago. He walks through Cambridge dead.
He might be carrying his severed head.

Marc Bolan

So diminutive even up on heels,
his eyes are two black craters; he commits
the lyric to an understated drawl,
a moody venom injected with hints

that it's not all an act, and the guitar
pursues descending phrases, solo licks
that vitalize a time peculiar
to his predominance, a glam guru

statuette-sized as Wagner or Lautrec
in a rain-storm of sequins. He is mean
in ways the audience demand,
untouchable, withdrawn beneath rucked hair,

a style, a genre without a precedent,
and soon used up, burnt out current,
no visible transition, one foot snared
in past successes, one without a hold

on shifting, earthquake ground, a silver boot...
The myth's to die incomplete, unfulfilled,
and sometimes it proves a reality,
a miscalculation behind the wheel,

the car's tin can concertina,
all aspirations left illusory,
uncontactable, sirens everywhere,
a crow taking off to a nearby tree.

David Bowie

Today the street-wise emulate
things you abandoned years ago –
pantomorphic chameleon
changing colours like the gecko

from Ziggy's sequined leotards
to Berlin's stark cabaret clothes,
cradling your death-wish in a skull
before letting the whole act go –

setting the tone for the austere
soundless grey wave that broke over
an age drifting like a canoe
to the lip of a whirlpool;

the blue cinematic cut-ups of Low.
Post-futuristic, you pointed
a way forward every three years,
outstripping your discoveries

like a child the ingenious kites
he's flown once for the aerial high,
the baling out of an umbilical
constraining a scarlet sting-ray.

We think of you confronting a mirror,
contriving new facial geometries,
one green eye, one eye blue, with Picasso's
genius to find asymmetry

in angles and planes of a face.
The new mix will be pyrotechnical,
the sounding into zero – Major Tom's
cremated ashes buried in deep space.

William Burroughs

Bullet holes pepper the shotgun painting –
a yellow shrine with a black continent
patched up on wood.
The suit's impeccable, no lazy tie,
the knot perfect between blue collar points,
a grey felt hat tilted back off the head,
the face vulturine, eyes which have stepped in
to live with mental space and monitor

all drifting fractal implosions;
the man is easy in his Kansas yard,
his GHQ since 1982,
the New York bunker left behind, and cats
flopping around his feet, finding the sun,
picking up on psi energies.

He's waiting for extraterrestrials,
psychic invasion; we can bypass death
by shooting interplanetary serum.
Some of us are the deathless ones. He pours
a crippling slug of Jack Daniels.
The body can't function without toxins
or weird metabolic fluctuations.
He's waiting for the big event.

And has become a legend, now a myth,
a cellular mythologem.
His double's pressure-locked in the psyche,
for fear he blows a fuse, goes out on leave
and kills. He is invaded by Genet,
his presence asks for love, for completion.
The man wanders to his tomato patch;
his amanuensis snatches a break.
The light is hazy gold. He'll outlive death,
be here when there's no longer a planet.

John Cale

Symphonic dissonance. A viola
cuts worse than any whip. At Tanglewood
I smashed a table with an axe,
a form of sonic mania, a need
to assassinate harmony,
break things to their minimal components,
then stand back concussed by the noise.
Performance depends on paranoia,

the tension building like a hurricane.
Recording is the tight control
of fortunate accidents, improvised
felicities. Inside a studio
I'm Mozart, Wagner blowing themselves up
to rematerialize as unorthodox pop.

On stage, I've smashed glasses clean off the piano top,
decapitated a chicken,
declaimed like Artaud. And it's not enough.
There's a dimension to be broken through

called extra-sensory insanity.
I travelled that way once with Lou; the mad
empty the ash out of their ears and eyes.
They watch their heads float off into red skies.

I'm waiting for the big experiment,
the potentialized fuse inside my head
to blow, the ultimate schema take shape,
the one that leaves all other music dead.

Nick Cave

Turning the black bread into gold,
rhinoceros hide into silk,
his voice has come from a dry well
to terrorize a Hamburg club,

dragging its vocal roots from stone,
from bottomless white-torrented ravines,
lifting up vision on a mental beam
to find in that transparent cone
the microdot, insanity,
a bug-eyed, Artaudian faced red flea
adroitly roaring into flame:

the madmen run like birds across a roof.
Prophetic blues. His face has come from Poe;
emaciation. Who can live out there,
survive and retell the story

in its miraculous simplicity.
Reaching into a song means twisting out
its central nerve, reinducting the words
into a bitter ceremony, smoke

filters bluely from his voice. Berlin, New York,
his act is dementia, a power that sands
the audience, desert grit in his speech,
and beating at his shoulders, leather birds.

Jean Cocteau

A cigarette in every thin finger,
the face depicts the inner map, the routes
to manic expression, every gesture
is translated into a form of art,
a new becoming. He's on overdrive:
a book, a film, a spontaneous poem,
a finger sketch, telephone calls, letters –
three parties to be attended. His blood
incinerates from overwork. His heart
is scorched with arrows. Their long black plumes burn.

And still the work's in deficit; the smoke
around him filters from a volcano.
The prototypal pop-star, his shirts,
reversed jackets, ostentatious neckties
were fashion-leaders. If we wear ourselves
inside out all the symbols show,
personal obsessions: that's how clothes express
the individual, that's how poetry
expresses all. Cocteau at Cap Ferrat
wearing the wind as a luminous dress.

Leonard Cohen

Gravity. Singing from a hole
into the underworld, having the dark
rise as a column on the march
to meet the sun. And all those years ago
a thin man picking out a melody
at the Chelsea Hotel, an elegy
open like a rose in a water glass.

And the lost children, where have they all gone,
where are they going to? A lover stands
each night on the same train platform
waiting for someone who never arrives,
the perennially missing one. Cold hands,
he's written a name on cardboard,
big red letters, and nobody responds.

The songs evoke the narrative
in which we're all involved: impermanence,
and how sex is the best insight to truth,
and when we write a shadow underpins
the page, and keeps track like a snake
of where we're going. Back to poetry

as the first measure and the last,
somebody singing to themselves at night,
their voice attracting words the way
moths spot crazily at the light.

Julian Cope

A purple hare jumps for the orange sky
and I'm on all fours with a turtle shell
strapped to my back: a World War Three helmet,
my right hand pushing a vintage toy car

through grassblades, levelling a sort of road.
I am the crazy one, the acid head
seeing each second as apocalypse.
My hand turns into a white butterfly,

my toes are mice squeaking inside my boots.
I tore my stomach open: it was art,
this exploration of tissue frescoes.
Some nights the audience are TV snow,

just buzzing unrealities. I need
incessant overdrive, a microphone
that's like a Duchamp exhibit.
It's not me on the speakers, but a clone

overreacting to a low-key show
with an impromptu, histrionic rage,
a leather posturing. When we are two
I blow the performance, ersatz Dada

replaces what I've got, a melody,
a lyric voice, and when I die they'll be
waiting for me, extraterrestrials
there at high noon in 2053.

The Cure

A plaintive, monotonal elegy,
their music raises a grey cenotaph
in a walled garden. There's an elephant's
proboscis picking up a silk top hat,
and someone, is it Alice, spiking tea
with acid, staring in a cracked mirror

at an image that's coming clear –
a bruised off-centre lipstick scar
a haystacked fun-wig combed out to spiral
curlicues, the loose polka-dotted shirt

a statement on obesity
that's not disowned: and the insistent bass
creates a line that hits the diaphragm,
an unrelenting urgency
to have the mind fracture against a screen.
The burn-out is like Jayne Mansfield's pink car,
a framework of Kenneth Anger stills
exploding in the head.
 It's red, red, red,
and black, black, black,
and grey, grey, grey,

an urban psychedelia
directed nowhere special, or coming to rest
in wastelands where a big black cross
erected out of scrap metal

points to the highway. Vultures flying West.

Ray Davies

The lyric art. Words as they fit a mood
the way ideas work from a drawing-board
into a shape and colour, a silk bolt
finds a ruched contour. What's in style
and out? He's measured the decades

with gravity, humorous irony,
a deadpan English wit, a melody
that tinkles off into a July day
and keeps returning, turns up years later
as though it needed to be forgotten
to prove a durable value.
It's done with such facility,
his reading the small moments in our lives

and building on them, something that he's kept
his own, a human in the world of pop,
composing on a rainy afternoon,
a glass, a rose placed on the piano-top.

Brian Eno

The anti-musician; a daylight owl
withdrawn to Suffolk. It is wide landscape
he gets into music, tonalities
suggesting ambient colour, blue, green,
at times a minimalist white or grey;

the sound's chameleonic, it adjusts
to mood. I might think of two sleepwalkers
colliding in the middle of a field,
and neither waking, just continuing
to float above the ground, or astronauts
stepping out on the red rubble of Mars.

Or sometimes it's the voice attracts,
as in *Taking Tiger Mountain By Strategy*,
the lyrics sounding like a joke between
Tzara and Erik Satie. The background
composer is a lecturer,
no longer dressed in boas, fishnet tights,
that drag-flirtation with Roxy Music
decades ago, but treating tapes,

evoking atmospherics. Found music
expressed with deadly precision.
Two hares are boxing on the lawn.
A blank man sits cross-legged in the attic.

Marianne Faithfull

The sixties are a loop in the time-film,
pacifism, pot, a blazing decade
extended like a summer through dog-days
to a mellow shimmer. They've gone away,

the ones who expected to change the world
in velvets, lace, the flower-children who sat
up all night with guitars. They disappeared
or recycled themselves in the brain-fade

of too much acid. All the kaftans, beads
were left behind as though a tribe had faced
extinction, and cleared off into the hills.
You were part of that damaged exodus,

one of the rejects hooked on methadone,
excess, smashing the glass to find yourself
without a face or torso. Through the hole
are glass splinters, a blue pigmented wall.

And then that raw whiskey-burnt voice came through
with *Broken English*, concentrated pain
feeding each song, a way back into life,
an affirmation that it could be done,

anger and re-birth redress the balance,
point the way to a continuity
for a blonde Billie Holiday; cracked timbre
evoking in part a Brecht cabaret

singer, someone leaning by a piano,
inhaling on a red-tipped cigarette,
feeling into a sad song and assured
despite the shadow, the plaintive regret.

Goth Pop

The blonde one scratches a guitar solo,
a needling antipathy to the crowd
packing the stage; his mean virtuoso

phased out by bass and the singer's return
under the pooled spotlights. Red, blue and green.
They're laid back. Only the encore will burn.

New songs are aired tonight. They're hermetic,
minimally arranged; the dark squeezed out
from a grey lemon. Shrill feedback, static.

The band play on the edge; a lyric flash
has purple thunder break on the highway.
A red car activates a head on crash.

The initiates lean towards each word.
In fun wigs and jagged leather, they're a cult.
They live by intimation, lines half-heard,

a stuttered eloquence, drawled monotone.
They're nearing the penultimate death-push.
The singer's backed up by a gel-haired clone.

Crouched low, a cortège behind dry-ice screens,
the song drags to an improvised climax.
Drugs are the problem in her hung up teens.

They end abruptly; the song's slashed in two;
and leave the crowd with the expectancy
of the killed number and of course they're through.

Debbie Harry

Reactivating glamour with panache
no one up front had been so consciously

an echo of a Hollywood screen-star,
a reversion to a Vargas pin-up,

blonde hair having us think of a movie
in which a woman sits facing the bar,

and when she turns round even the clock hands
momentarily freeze, her oval face

emphasized by a satin lipstick bow.
And how the music mainlined energy

into a youth junking celluloid rock,
the micro-skirted, thigh-booted singer

tinting the lyrics pink and blue, pouting
romance into that street credibility,

having us think of a big orange sun
dramatically setting over New York,

a woman making up in a mirror,
dusting sequins on to a powdered lid...

Melodic pop, vocal translucency,
she means no more than what she gives away –

the dream we have of a love lost or found
just as it brightens one rainy Sunday.

Jimi Hendrix

The fuzzbox virtuoso
cherokee. His blues voice talks to his guitar's
distorted eloquence, there's nothing he
can't afford an improvised melody,
hair tied back by a scarlet bandanna,
his chords so individually

his own, they characterize the sixties.
Take a flamboyant cocktail of mixed drugs
and run naked into a turquoise sea
and that's a J.H. song. A mauve starfish

opens to reveal an interior
in which an underwater city shows.
Small fish swim in and out of someone's eyes.
He keeps the vision. Later, it is wild,
his punishing, phallic solo,

his using the guitar to emphasize
a sexual geometry, building a storm
around him, a circular hurricane,
the sort that picks a house up like a toy

then drops it in a tidal wave.
He's tuned to something deep black as the night
which tears him out of life, attenuates
his earthing, pulls the switch on him,
fuses the mains which read House Lights.

Billie Holiday

Reworking cadence, when she finds the note
it's always different, singing without words
at the Apollo, letting her drift float

with the blue smoke plumes from a cigarette.
Style's in her spacing of words, Lady Day
a white flower in her hair, leading the set

wherever breath dictates, a mussed lipstick
tinting the song, one hand placing a glass
back on the piano top. It's not a trick

to catch the spotlight, but a need. Up there
her isolation is complete, she finds
a means to centre it, and takes us where

there's consolation for a spike-heeled fall
into back alley junk. 'Gloomy Sunday'
is slowed to speech. Leaning against the wall

her back contains the storm. She feels the past
as a pivotal hurricane, and lets
the saxophonist punctuate the cast

of figures she inhabits; it is hard,
maintaining poise, creating out of pain,
bowing out at the end as a reward.

Michael Jackson

He wants to be La Toya. It's her face
he copies by the line, a geometry
that eliminates gender, points the way
to a reconstructed species. He's high
on dance, the generated pheromones

leave him ecstatic, it's a solitary
exploration of inner light, the beat
of an automated android consumed
by mirror images – he's reflected
everywhere in the mansion, and his feet

won't walk, they look for rhythm, instate speed.
Reclusive, air-sealed by security,
a legend to himself out in L.A.,
surrounded by pharaonic monuments,
an emperor's exotic menagerie,

Hollywood mannequins, he's grown into
the ultimate parody of a star,
military jackets splashed with braid, his eyes
shielded by dark glasses, a permanent
regression back to youth – how can he age

inside the dream that he's alive? He sits
beside a panther. He's always on stage.
The world outside is a receding point,
an abstract notion, and the drum machine
is on, computing faultless dance-floor hits.

Three Decades of Jagger

And that's too little for uncompromise,
raising a whiphand to conformity;
the skinny, unkempt schoolboy in hipsters,
mean with maracas, pulling a surprise

on the establishment's dead machismo,
daring to make a fashion of long hair,
high-heeled boots, pouting so the negroid lips
made the wide ovoid of fellatio

around a phallic microphone. And live,
so dynamized, an electric dervish
slowing to a falsetto blues; few thought
your hyped-up extroversion would survive

more than a year or two; but you had air,
that unnamed particle which once released
is self-expansive, power that blows through walls,
its hard pressure pinpointed in your stare

that goes on holding crowds in abeyance;
now it is mega-stadiums, hard rock,
and you're still energized, youthful, a slap
to the disclaimers who you will outdance

a lifetime. You're from Egon Schiele's art,
one hand on the hip, a contortionist's
agility – prototypal rebel,
we think no love-arrow could pierce your heart

because you're everyone's. And what you've made
from public confrontation is a role
that liberates and grows to a statement
about ourselves; how we are less afraid

to be the individual. Look, you say,
the age grows with us: the music is tight
and graduates, the vocals pitched up high.
The town is closed because you're on today.

The Jesus and Mary Chain

A mean reminder: post Velvets feedback
behind dry-ice; it's a vicious whiplash
at techno-pop, black shades, drug-removed cool;

it could be circa 1966, pop
as a form of instrumental algolagnia
with Andy Warhol writing *Cock*,
Melanga under strobes in a whip-dance.

Today, the imitation's tame;
the microphone's a black lily.
The guitars crackle, but the words don't find
articulation; the delivery
escapes through a bullet-hole scored in the stage.

The men in black. The Becks bottles
accumulate; indifference
is like the wrinkle in a leather boot
lifted to stub the floor.

'Some Candy Talking', 'April Skies',
and outside it's the knuckling London rain,
or the sky lifted like a table-cloth
to suggest blue undertones. When they stop

the tongue is furred with lemon, bits of pain.

Brian Jones

So delicate an intrusion on noise,
a sitar, harpsichord, peacock's feather,
always the right tone in the melody,
a slide-guitar or dulcimer, blonde hair
shielding the eyes, no gender clue

offered in the lace blouse, mandarin coat,
jewellery picked up from Saks Fifth Avenue,
velvets from the Chelsea Antique Market.
Rejected, one way through is to mutate

to a new species, go away from life
and re-invent it, become solitary,
the only one looking out for others.
In time, the mutants, trans-people arrive
and infiltrate at festivals.
They are the enlightened ones, dressed in gold,

they live behind the hills or else nowhere.
It's a story of degeneration,
how drink and drugs get into overdrive
and how the fingers no longer find chords,

but tremble. It's the myth of dying young
recurs as a brutal reality.
Brian Jones face down in his swimming pool
murdered one sultry July night,
a ritual sacrifice to the sixties.

John Lennon

Arriving out of nowhere. Retrospect
reads revolution into accident,
somebody breaking into a decade
to invent the sixties, stand on its head

post-war inertia. The black knitted tie,
fringe to the eyebrows, stack heeled boots replaced
by kaftans, Indian beads, an acid trip
standing a forest in the sky;
a little girl rides on an elephant
out of her dream into another dream.
The universe fits neatly in his eye.

Banging a piano in an empty room,
New York outside, it all happened too fast.
He searches for a melody
to clarify the changes. He's withdrawn
into another vision, white on white
or black on black, both are the same
keys to invisibility.
The songs are messages, and they return
to we who listen as the sunlight falls
over the late part of a century,
deciding what is gone and what will last.

Madonna

It's all a question of identity;
someone is lost inside the mutations,
the years which happen fast, schematically,
the boy-toy act in jeans and cap

growing to be a Monroe look-alike,
blonde hair falling as though blown by the wind
emphasizing whatever facial plane
is explored from behind a mike

or angled for the lens, paparazzi
hassling for every off-mood shot –
the smudged lipstick or baggy overcoat,
the private person eating green pasta

in a small restaurant, feeling for space
after the provocation, topless thrust,
the body a sequinned snakeskin
transmitting white heat, an electric lust

wired to the music. And behind the face
is the new one awaiting invention;
Madonna in orange velvet leggings
dropping popcorn nuggets into her bra

at business meetings and retrieving them,
her tongue a corolla between red lips.
It's the emptiness of being a star,
the dehumanized ennui has her change

persona, image. She would like to be
both sexes: gay-male's her alter ego,
experience every kind of orgasm;
but now, just stares out at the New York snow

from a dark blue couch, relaxes her curves
after the gym work-out, the jacuzzi,
and wishes she was a snowballing child
whacking impacted ice at a dumb tree.

Man Ray

We polarize the image. An ethos
of visual immediacy.
The camera reads the age in which we live
deleting old forms of biography;
black and white laying flat how we're arrived

at where we are. A New Yorker in France,
a versatile, pictorial anarchist,
hooked on Dada, cooking its lobster's claws
first savage-pink, then pepper-red,
meshing into cultural pluralism,
getting their faces known, Matisse, Joyce, Stein,
Picasso, Cocteau, Ernst, Rrose Sélavy,
the introduction of celebrities

into collective consciousness;
rayographs, solarized portraits,
the image-maker using Ponds Cold Cream,
a darkroom thermometer as an earring,
a fishnet patterned hair-net on a face
and hands, an ultra-violet nude

as signs of provocation. Smash the old
so inner momentum accelerates,
implodes as a wave on which Breton surfs
towards huge scarlet lips in a blue sky.

Man Ray transforming whatever he touched
into a quirky aesthetics, and how
they live, Nancy Cunard, Nusch Eluard,
the Marquise Cassati, and a model
whose hair and lips and eyes and face are gold.

Freddie Mercury

And so a generation disappears,
begins to die, divested of the myth
that there's never an end to youth.
Red leaves in midsummer, a bright pink flag

dropped to the sidewalk, crumpled there,
a big house left behind, the things you loved,
antiques stashed with an insatiable need,
grown unfamiliar, floating in air.

Few ever have your dynamic,
rock operatics, projecting on stage
with the theatrical vivacity
of a hybridized Jagger/Nijinsky.

Such generosity right to the end,
not making death into a public scar,
but privately withdrawing, shutting out
the paparazzi, living with the fear

until it becomes the oddest of friends,
the irreconcilable as it leads
the way through the last tunnel into light,
or so we hope, although we'll never hear

if it's all right with you, we'll never hear.
And what you leave us as a legacy
is less disposable than you preferred,
a vocal imprint, its diversity

anticipating, creating a genre
where others follow. It's a London night,
no car collects you, you come a last time
to face a window and dip out of sight.

Jim Morrison

Somebody always has to disappear,
and so the myth travels the way a seed
blazes into a red poppy
beside the road. Tatters of wind-nagged silk.

The voice can't change now. It is posthumous;
a sixties' product. I can hear it scream
out of a wind-tunnel, an underpass,
it seems to issue from a blueblack dream

in which the figure standing at the bar
turns round to find the world has disappeared,
he stands on the edge of a precipice,
nothing behind him but the radial star

his whiskey tumbler smashed in the mirror.
The bottles are all empty. Jack Daniels,
White Label, Jim Beam, a drained Cutty Sark.
The bar-tender walks straight out through the dark

and floats to nowhere. Unshaven, obese,
Jim looks for handholds. If he tries to sit
on the stained counter he'll have vertigo.
What he misses is the microphone-stand,

getting off on stage, fast adrenalin.
Is this Paris or L.A.? Night or day?
He suffers from a drugged amnesia.
A blue snake winds itself around his hand.

He'll stay here, drinking like Malcolm Lowry,
until his vision clarifies. Out there,
a red mountain pushes for a gold sky.
He'll climb there later to meet a black bear.

Morrissey

Moribund, and morosity
is like an empty grey building,
the windows punched out on the sky,
the aerosoled pink graffiti

proclaiming a dead Weltanschauung.
Holed up at Manchester's Midland,
the man entertains his mystique.
It's like a vulture sitting in his hand

quizzing his eyes and waiting for the kill.
It keeps him celibate. A friend
is someone who walks out of a mirror
on dark days when a taxi calls

delivering a heart-shaped box
not to be opened right until the end...
Inside is a portrait of Oscar Wilde
or a bullet noosed in a red ribbon?

Pop music is his addiction,
without it he'd disorbit, decibels
are supernovas in his brain.
Outside, it's a thin fuzzy rain

turns everything to sepia;
the street's a 19th-century photograph.
He riffles through old 45s,
a vinyl fetishist for whom the past

elicits meaning. He sips at cold tea.
A sixties song resuscitates his mood.
He embraces his vision. It's the blue
of old forgotten films, of solitude.

The New York Dolls

A glitzy, street-queen, glamour drag,
red vinyl boots and combed out wigs,
still raw from Rusty Beanie's Cycle Shop
armed with a street-snarling sonic assault,

the archetypal garage band
lifting their sound from late sixties Detroit
through hints of Jagger to a hard
pre-punk extravagance, a hit and run

freak show, playing to immolate
every last vestige of themselves,
Jo Hansen's vocals making poetry
out of the trash of life, pinning rhinestones

to dead rodents, burning with style,
contorting round the mike in a top hat,
the transient doyenne of the Mercer,
ringed fingers swinging a dead rat,

the voice more resonant, concentrated,
than anyone around. A brief entrée,
a blade-swishing provocation,
too fast, explosive to have staying power,

projecting a meteoric eclipse,
then dissected by others, bit by bit
built on as something seminal,
transvestites playing like tigers in a pit.

Johnny Thunders

Just half alive, or not at all,
each performance like an obituary
still lacking the conclusive date,
a pre-initiation rite, the man
has presence, make-up, a lace shirt,

a cigarette inclined from vertical,
a compulsive attraction to OD
in public. There might be a friend
waiting at the end of the night,

but he's not showing. Daylight vision seems
more like a Brassaï photograph;
a pusher waiting in a bar
that never closes. You were rumoured dead
so often, but the audience came
knowing you'd be there just the same,
terminal, slurring at a stumbling pace,
and sometimes calling out for a doctor;
rehashing the old set: your heroin

panegyric, 'Chinese Rocks', or 'Born to Lose',
'In Cold Blood'. It was attitude
sustained you through dissolution,
playing in a French sailor's cap,
a blue Edwardian coat,

always by that remove a star,
a death-cult celebrant so spare of flesh
it couldn't meet on your body,
now driven away in the final car.

Shooting a Pop Video

The weird perspective's created by props,
a massive cupola-shaped chandelier
is let down from the ceiling. Mannequins
are placed like birthday candles round the edge,
each with a cigarette angled
from scarlet lips; and the mime-dancer stops,

amazed at finding his transvestite's face
copied in each cloned mannequin.
He lights a cigarette and stands stock-still;
it's like he's being hunted by guitars
which enter spookily, laid back
reverberations, hesitant, a ricochet
dispersed by echo-chambers, returning
with a vehemence which might kill;
a massive wall of sound across which stars
explode in maniacal reds and blues.
The dancer appeals to the twenty clones,
and each responds with a bright splinter-tear,
his vocals introducing Jacqueline,
half of whose face divides each mannequin.
She is the sultry one he met by chance
on a deserted beach. Her hair's so black
it is a thunderstorm. Now full facial,
she's everywhere looking at him,
her body moulded into black sequins,

but he can't claim her. She is blown away
and the guitars continue their attack.

Nico

And wasn't death always the one image
in the draped mirror? Lift the cloth and see
the *doppelgänger*, the bleached out xerox
of a drugged, upside-down identity

hung like a dead fly in a broken web.
The voice was posthumous. It seemed to call
from buried cities, an unmapped desert.
Each syllable meant juggling a stone ball.

The blonde Factory model just went away
into subjective exile. It grew real.
Forgotten, hassling for a new uplift
the arid years had her expression feel

for new beginnings, less severity,
a re-enacted drama. It was hard,
maintaining a harmonium with guitars,
sensing each heckler's voice twist like a shard

piercing a nerve-end. Always dressed in black,
imperturbably dignified on stage,
success came again late, and already
the snake had left its imprint on the page,

a sinuous insignia, contract
with where we go after the last heart-beat.
She lights a cigarette. 'This is The End,
I'm singing, but I'm dying on my feet...'

Edith Piaf

The stage is my one shelter from the world,
invulnerability around the wound
of red roses thrown at my feet
at the Olympia or Bobino.
The spotlight integrates dualities,
I am a girl again out on the street,

singing to stay alive, singing to eat,
my cracked saucer extended to the crowd.
Out here, I'm safe; my drugged, tormented past
stays in abeyance for an hour.
The music insulates. That is my way

of sobering the manic chimeras;
the morphine I'll needle into a vein,
the scenes I'll create later, wedging jewels
and money I've earned down a Paris drain,

the hangers-on who I can't turn away,
crowding the dressing-room. Sometimes I scream
and realize that this isn't a dream,
it is my life, this broken champagne glass

got like that when I tore my dress
and set fire to my hair. My voice goes out
to reverse fortunes, losers and winners
in love and life; the poor, the deeply hurt
are closest to my heart. I'll leave this earth

with nothing, I who was born in the street,
swaying on stage to keep upright,
praying I'll get through and it's the last night.

Iggy Pop

Fire-walking, fire-eating contortionist,
a manic shaman slashing his torso,
the mike's a phallus in his Reichstag fist,

his razored denim's unzipped, leather belt
notched for the emphasis of narrow hips,
this man would have taken a Sadean welt

and cultivated it as a red snake.
Launched, and relaunched again, short-circuiting
on drugs and liquor, crawling in his wake

to resurrect his body from white ash,
this is the self-lacerating raw punk,
binding his gutter scars with a silk sash.

It's Berlin, circa 1976,
the Thin White Duke composing backing tracks,
an ominous, plangent, funereal mix

for the elegiac 'Sister Midnight'.
A new start in a musical ethos
scrambling its brains on stage, a red spotlight

finding a nose pierced by a safety-pin.
The art's survival; mangled, right off cue,
then focused in his rage, his ravaged skin

manifesting years of seething attack,
this is the cult effigy, up-ended,
still singing, spread-eagled, flat on his back.

Prince

I sign my letters God. It's all an act,
pansexual mystique, a wordless walk-in
communicating by telepathy.
My brain's a studio. My human pact

is with that unit, innovative sound.
My yellow custom guitar's polyglot,
I smash the frets and work all day, all night
at Paisley Park. My inspiration's charged

by air-waves, rap, house, funk, psychedelia
interchange in my musical texture,
and Purple Rain's the one that comes out right
on stage under the satellite lasers,

the sexual rhythm which is so off beat
from flesh, it's like my microphobia,
the clothes I wear twelve hours and throw away.
Even rehearsing or lying in bed

I'm made up like a star, a magenta
nude body, off-the-shoulder trouser suit,
and then there is my button fetish, eight
on each cuff, high heeled ankle boots with zips

made at the City Cobbler. Mannequins
dressed in my old tour clothes watch me record.
The less I give away, the more I am
inimitable. When I keep a date

it's with myself. Jimi Hendrix, Sly Stone,
I've incarnated both in my ego.
I pray before I go on, then the buzz
electrifies. It is the only show.

Lou Reed

Your blue tinted shades turned defiantly
towards the interviewer; a cassette
recording the embarrassed silences –
no concessions, no easy admissions,

your past under black wraps – the Seventies
furor; a peroxided leather-cat,
speed-freak monotonal delivery,
burning the issue of gender –

N.Y. back-room bars, transvestite parades;
the man who fried shit with his spam;
your narratives loading the air.
Smack. And you out of it on stage,

somnolent, jarring from a white cocoon,
but still a pivot directing
an irreversible power-beam.
The scene has changed; you work more secretly

more dangerously in the studio,
lashing our social wrongs, elegizing
New York, placing each journalist
on the cutting-edge; words

are what they never understand;
you lucid after ten whiskies,
turning a subject on its head.
All past achievements blow away like sand...

Keith Richards

So laid back, living where his dimension
touches on inner vision, that far gone
he wouldn't notice a black spotting fly
settle on a cheek and a second one

glint as a double beauty mark.
Heroin as an embalming fluid,
a cellular rejuvenator, he's
like Burroughs, a human experiment

in survival. Fortified, whiskey-shot,
the music lines are always tight, the nerves
feel into that non-committal control;
the man lives for the chords he generates,

and is a kind of latter day Crowley,
an adept of a deathless state, someone
who guards somatic knowledge, most alive
confronting stadia; knee boots, jewellery,

fetishistic tinctures of Joy,
hair brushed in every way that's contrary,
the archetypal rock star, maintaining
the image as reality

through so many mutations, Swiss clinics,
and in retreat at Redlands, someone who
finds a centre in the crazy decades.
'I'm dying, but that means I'm living too'.

The Rolling Stones

An unrestrainable storm's energy,
a blues tornado building year by year,
smashing successive decades like stage-props
into a singular reality –

the music's drive, and how Keith Richards loads
that power-line with such a laid-back style
he might be anywhere the drug dictates;
and now in high key the dervish explodes

frenetically, adopting a persona
for each volatile lyric expression,
a manically improvised Lucifer,
a lashingly exploitative 'Gimme Shelter',

a transsexual identity which dares
contain a crowd that's like an exodus
come across country for the new ideal,
and with the red light on, it really scares,

Jagger's psychopathic 'Midnight Rambler',
cued up to stick a knife right through the throat,
a pyrotechnical 'Jumpin' Jack Flash',
no ostentation from the bass-player,

it's all up front by a shared microphone,
and what was revolutionary is still
an ongoing assessment of our lives,
survival, altered consciousness, a tone

that challenges the way we live and think,
and devastates the old world, moves into
the centre of new chaos, while the pack
flail for the singer on the spotlit brink...

Roxy Music

So coolly unintrusive, one remove
further than most, the vocalist arrives
as though he's singing in another room,
evoking places, baroque cabaret
in a lost château, and the sequinned girl

removes a scarlet elbow glove
to mime the taking of a stranger's hand.
It's style he imposes, the spotted tie
worn in a way that's unfamiliar,
the hair strands never displaced as they fall

towards the right eye. It is always night
inside his intimately detached tone,
a cobalt limousine slicks through the streets
driven by a mannequin; a red boat
drifts in slow circles across a lagoon.

And when the music jumped texture, provoked
the unpredictability of stairs
encountered in the dark, it was Eno's
treatments devised that flare, atonal noise
that seemed to come from inside a hangar.

Mostly an image; the singer pursues
illusions, lets you in on how things are
inside a smoky club, the chic glamour
surrounding party time, with just a hint
of what it means to have the late hour blues.

The Sex Pistols

The nihil. And annihilate
the stage we're playing on, the plutocrats
in imported pink Cadillacs,
record emporias. It's anarchy
this war on ourselves and the audience.
We're Fascist Dada. Play to kill

and issue body bags. This club's a barn
packed to ignition, and when I convulse
it's really epilepsy. Sid's back there
so out of it on smack, he wouldn't know

if he was underwater. We can't play,
we're here to lacerate ourselves
in a blood-letting ritual.
I did it my way. Not like Sinatra's

vacuous insincerity,
his words embalmed in acacia-honey.
Mine come out like the points of nails,
a twisted, shrieking, heckler's wail,
hysterical trajectory.
Our venom scorches. We're not here to stay.

Orange Disaster

An orange wall faces a black. Two white
are contrasting opposition. The one
who buys up Warhol's diamond-dust portraits
uses it as a studio.
He calls it an oriole facing snow.
His Bavarian visitors come twice a year
and talk of being Europe's rock-garden.
They bring him blue gentians and the digitally
remastered songs of Edith Piaf.
He flies his own flag. It is Klimt's *Danaë*,
and on the other side a stars and stripes blue sky.
If he could instigate it, there would be
 black snow
falling from a green sky and oranges
suspended above the city,
dropped there and saved from a pulped disaster
by a trick of gravity.

He sleeps alone or between his two guests.
His inheritance never fails,
it's like pure water leaping through a rock
to sparkle. He goes with the flow.
The world outside has let him down.
It's too predictable. Rather he would have
 orioles
drumming at his window and red summits
surround the neighbourhood. But it is dawn.
His friends are sleeping. He gets up to think
and fills his studio like that.
He peels an orange, wears a clown's black hat.

Siouxsie and the Banshees

Black, as a fashion mood, an image mood.
Black everything. At first vampirical
and now a top-hatted sophistiqué,
the lady's journeyed through the underworld
consulting mirrors, an Egyptian queen,

mummies sleepwalking across red deserts.
Her voice intones, is an incantation
across blitzkrieg guitars, or a sitar's
evocation of orients,

shooting-stars burning through a hole in space.
A fishnet body-stocking, leotard,
or moulded black satin hot pants,
hers is a gothic cabaret,
a Mae West, Eartha Kitt update,

bringing gloves back as an accoutrement
to style, always so unexpendably
the individual: she is black on black,
the after-image of herself,

self-immolation of the allusion
to white noise, jangled percussion,
a music standing buildings in the air,
a grey asylum, a gold pyramid.

Secret in Notting Hill, or lost somewhere
in inner flux, she's distant. It is night;
the planet may be transformed while she sleeps,
the day break to leopard-spotted moonlight.

Rock and Poetry

One feeds the other. It's the subversive
I value – speed injected into words,
the volatile flash lifting syllables
into a rain forest of coloured birds,

a storm of scarlet, green and gold.
Poetry needs street-cred, an energy
vital to youth; two standing out the rain
in Greek Street, reading their own memory

of now and what it means to be alive
in someone else's words. *He* got it right,
rain moving in and out of a blue cloud ridge
makes brilliant statements about the light,

accents the April day and tinctures it
like the black corolla inside a flower.
And there's another way to make it live;
her Walkman starts to crackle with the power

of menacing feedback: a voice cuts in
that's separated by the mix; it too
speaks of an up day through a minimal
novella; a red car pursues a blue,

the girl smiling at the boy at the lights,
then slipping away into dense traffic
is lost for ever, an elusive blonde
he thinks of in his solitary attic,

and the guitars chase her all over town...
It's a dynamic: rock and poetry
meeting in individual ways
to make sense of our age, of you and me

welcoming each liberative gesture
that gets us nearer cutting the ribbon
on impositions, living to the full
and celebrating how that freedom's won.

Patti Smith

Delirium. A meteoric blaze
at CBGB's and The Bottom Line,
a cocktail-shaker of mixed drugs
imploding, thin as a light-flex
sustaining megatons inside a bulb

which had to blow; the Keith Richards' hairstyle,
emaciated grandeur, street poet
in bondage chains, guttural, whipping lines
to stinging lariats, hyped-up to bring

an epicentre to the stage,
an apocalypse of flaming horses
running headless for a ravine
in which junked cars are smashed to nickel cans,
and there's a woman in her pointed boots
celebrating the debris, stomping hard

on a black Cadillac's bonnet.
Music meant auto-combusting,
pulling hysteria out of the throat
as a volatile fizzing coil,
a hit and run killer crouched at the wheel...

We look for her through fire. It's dead ash now,
the whole impulse defused; the dynamic
remembered through her records, the wild one
like Rimbaud, temporarily vatic.

The Blue Hotel

We take quiet refuge there on rainy days.
The rooms are blue, cobalt and deep turquoise,
and sometimes pre-recorded music plays –

'Heartbreak Hotel' or 'Famous Blue Raincoat' –
Leonard Cohen's Clinton Street elegy.
The solitude surrounds us like a moat.

Above the porter's desk, I see it still,
hangs Gabriele Münter's Blaue Reiter friends,
the two reclining, while a dark blue hill

stands back from homogenous green grass.
The keys are all taken; no one goes out.
A central bullet hole has starred the glass

in a gilt mirror. A pink Cadillac
sits outside as the hotel's limousine.
We only ever see the chauffeur's back.

The maids wear blue suede shoes. Each day we find
red and white tulips arranged in a vase,
a neat ribbon-bow attached to the blind.

The place is in a forgotten quarter;
no cafés: warehouses, a cemetery.
We have novels and a tape recorder.

We're mostly silent. Punctually at eight
a blue rain falls; the singer's voice intrudes,
the old familiar 'Songs of Love and Hate'.

The Stooges

'Dance to the beat of the living dead';
they're like the paramilitary
on drugs, a video of what happens
inside a padded cell, a psychotic
cyclone, the singer in black body tights,

his naked torso cut with shards of glass,
his head-butting projection from the stage
aimed at the third row. It is suicide
checked by the impulse to get back
up there and crawl in chains, a captive animal
breaking all boundaries. Where do we go

when we're beyond control? The mind shoots film
so speeded up, there's just a whizzing blurr
of colour. When the power slows,
the last caption is of a car burning
in the Sahara. Then a red sunset.

Iggy's stage bottle-brawls with biker gangs,
no one intenser, more immediate,
his scrunched, chaotic glossolalia
maintained against a guitar wall,

his celebration of disease,
carnage, nihilistic ecstasy fed
through primal energy, his focused gun
pointed at one level – the head.

The Velvet Underground

Lay a whip across a piano,
you get a jazzed up Satie with DTs.
Improvise with tonal oscillation
slashed by a maniacal viola
and charge that up with anarchic feedback,

dissonant, sonic overkill,
before the dispassionate voice enters,
so cold it seems to speak direct
to a nerveless society, black ice

haloed around the head and heart.
And there's the girl drummer standing upright
in what is ritual: an ostrich guitar
flagellating repressed hysteria
before the scorching, atonal climax

to 'The Black Angel's Death Song', 'Sister Ray'.
Amphetamine, austere black clothes,
this is for real, no acting out a part,
no eye contact; a schizoid confusion
detonating Cage, Stockhausen,
creating a white noise insanity.

Nothing before them to express the age,
so fiercely, so immediately,
an evocation of the underworld,
sado-sexual rites, a buzzing New York,

a lyricism that goes for the throat
so coolly in its understated rage.

Scott Walker

Always in hiding, black tented shadows
projected by a blue mood, solitary
as a character in Dostoevsky,
he's somewhere and the only sound
is thought winning its own echo
or a voice concurring with a piano

about a loss of love, a way
of life renounced. Good singing is like wine
sipped for its flinty bouquet, and that voice
which got Brel's passionate anxiety

into so powerful a lucidity,
searched to discover in its resonance
a measure of the void. His songs went out
to reconcile the lost with pain,

played while the asterisking summer rain
fell through blue poplars and the park
emptied except for two who sat
out of the shower while the early dark
arrived, and pungent jasmine hurt.

The high cheekbones, the studied smile
so often lost to dark glasses,
the palpable, scarred sensitivity
fed into lyrics; now the man apart

has stepped into terminal solitude.
We play him and the years return, the days
in which we knifed on wood our first love-heart.

Andy Warhol

It's really *too much*, just being alive,
the Zeitgeist to a pop generation,
there's nothing logoistic I can't make
into an art commodity;
the trivial sparkles, it's like the diamond
pieces I buy myself at Bloomingdale's.
I'd paint a red ad on the bright blue sky
if it would stick; a day-glo skyscraper

positioned in the clouds. And being shy
means leaving a door locked on someone lost
in childhood, distracted by toys and things.
He'll never reappear; I eat candy
to compensate. Generations OD.
Jackie and Candy, Ingrid and Viva,
the sixties burnt me, I was high on speed,
my image fascination with Monroe.
I'm a pink sugar-mouse Marquis de Sade
to those who misconstrue celibacy.
Films make themselves. At studio 54
I bugged the place with cameras, microphones,
archived so many words. Who will replay
a decade's unrevised gossip?
I never threw a gum-wrapper away;

the time I lived in, every little bit
was assimilated. There's only now.
Death involves losing control over fame,
no ray-bans, leather jackets, Swiss chocolates.
Today, I found myself in Empire State,
and went unnoticed. I couldn't be seen.
I would have liked to screen New York is dead,
black as a central colour with some green.

Neil Young

That voice keeps intruding across the years,
thin, plaintive, catching a high note
out of blue mountain air, making us start
at the fragility of song
as though a flaw appeared in a blue pot

to be reintegrated without sign
of the least fissure. Such a long journey
through conflicting changes, acoustic, rock,
assassinating the predictable,

appearing like someone revitalized
from outback spruce and pine, a solitary
inheriting mountains and lakes
in a vocal timbre that's part elegy,

part celebratory of a stand
in which the singer burns to die,
autocombusts or slumps picking out chords
in some anonymous hotel.
A window open on white sand,

Pacific surf. A universal messenger,
he brings his intimacy to the stage
addressing how we're individual
and search for inner truth against the rage

of tyrants, dictators wired up on greed.
His voice rises like smoke above the hills,
it has become, to so many, a need.